S0-ATR-741

Wild Critters

Epicenter Press is a regional press publishing nonfiction books about the arts, history, environment, and diverse cultures and lifestyles of Alaska and the Pacific Northwest.

Publisher: Kent Sturgis
Acquisitions Editor: Lael Morgan
Designer: Leslie Newman, Newman/Design Illustration
Printer: Everbest Printing Co. Ltd./Alaska Print Brokers

Text Copyright ©2007 Tim Jones
Photographs Copyright ©2007 Tom Walker
Illustrations Copyright ©2007 Leslie Newman
Library of Congress Control Number: 2007922197
ISBN 978-0-9790470-2-2

Second Edition
First printing, March 2007
10 9 8 7 6 5 4 3 2 1

Printed in China

To order single copies of this edition of *WILD CRITTERS*, mail $9.95 plus $4.75 for shipping (WA residents add $1.30 state sales tax) to Epicenter Press, PO Box 82368, Kenmore, WA 98028, call 800-950-6663, or order at www.EpicenterPress.com

Wild Critters

Verse by Tim Jones
Photography by Tom Walker

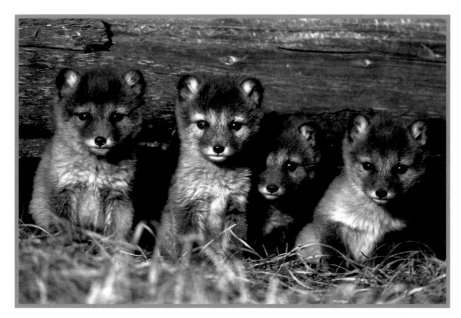

Arctic fox pups

Epicenter Press
Alaska Book Adventures™
www.EpicenterPress.com

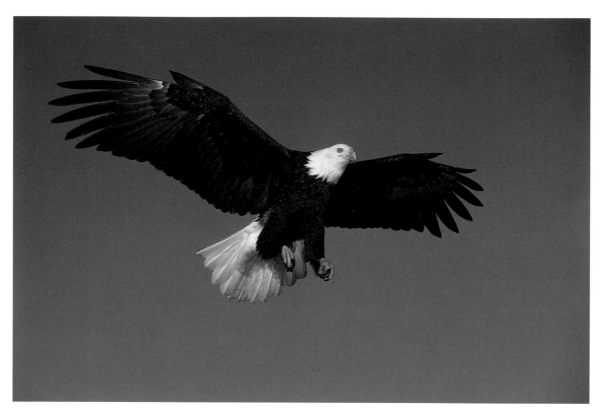

Bald eagle

For Mary Anne, Justin, Ariel, and Eric

With special thanks to:
Mary Lou Barra, Jon Goniwiecha, Barbara Jones, Dona Kubina,
Penny Mathes, Yeon Soon Min, Philip Munger, Gari Normand,
Nita Pardovich, Evie Smith, and Jim Swaney.

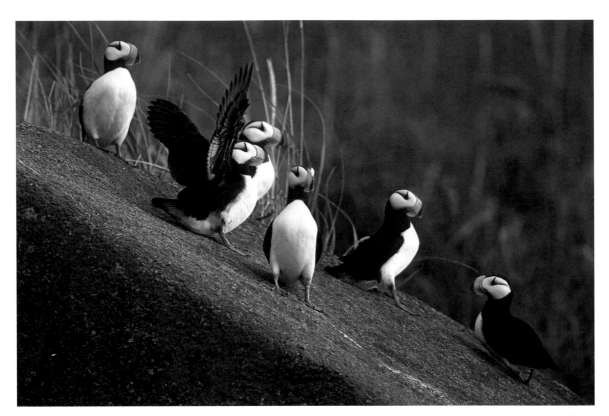

Horned puffins

Table of Contents

The sound of silence

8

In the spring
on the wing
you can hear
the birds sing.

In the fall
in a squall
you can still
hear them call.

On the ground
there's no sound
they don't want
to be found.

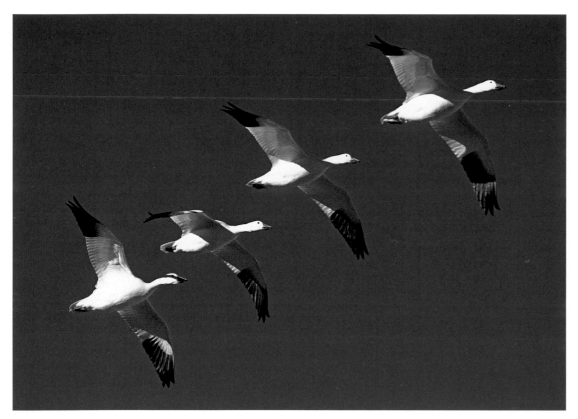

Snow geese

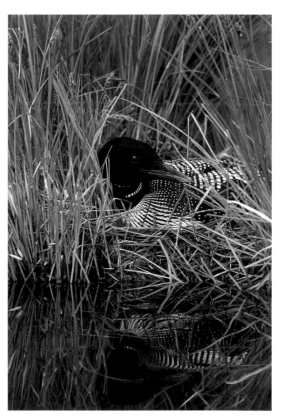

Common loon

A yawn dawning

Midnight sun
sounds like fun,
until you hunt all day.

With all that light
there's not much night,
to sleep fatigue away

With only dusk 'til dawning
I always wake up yawning
to start my new foray.

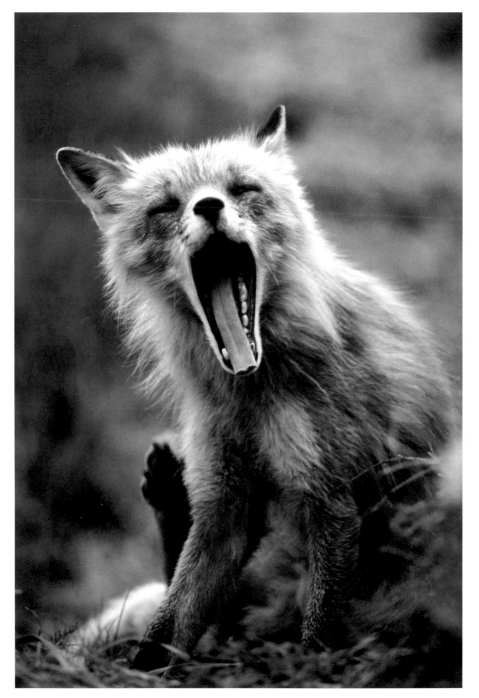

Red fox

Caribou Carrie

Caribou Carrie
stretched for a berry
and caught it up in her rack.

She reached for the treat,
fell off her feet
and tied a knot in her back.

12

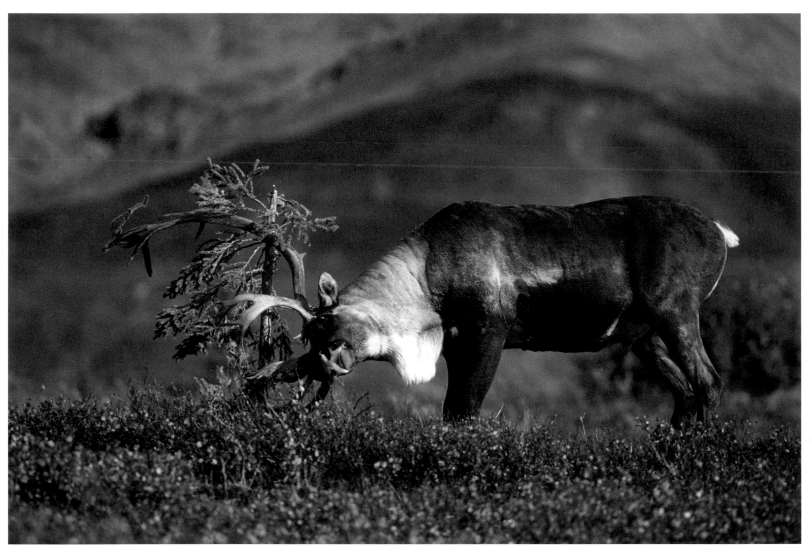

Caribou

One stuck duck

Dipper duck
ran out of luck
and got his head stuck
in the muck.
Ohhhh YUCK!

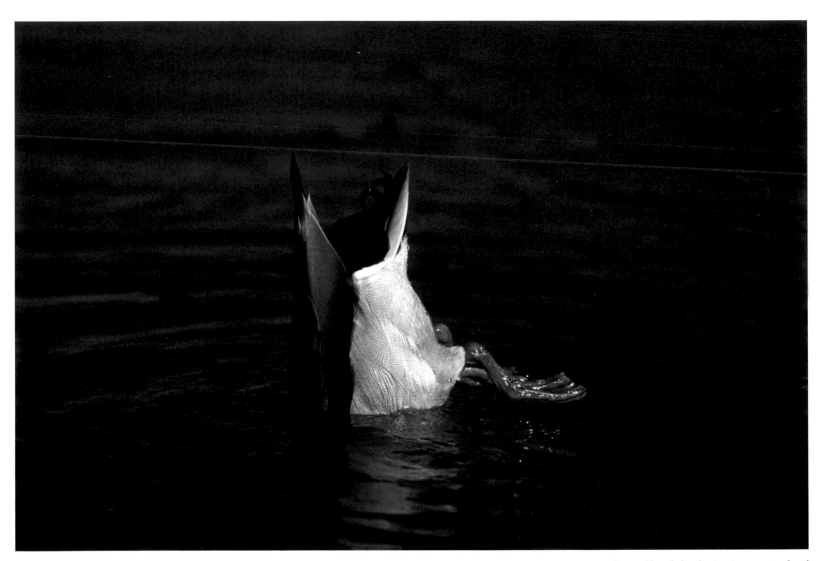

Male mallard duck tipping up to feed

Back seat loonacy

Are we there yet, are we there yet?
cried the little loon.
No, we are not there yet,
but we will be there soon.

Are we there yet, are we there yet?
cried the little loon.
No, we are not there yet,
why don't we sing a tune?

Are we there yet, are we there yet?
Still the same old beat.
No, we are not there yet,
why don't you try to eat?

Are we there yet, are we there yet?
Her call was still the same.
No, we are not there yet,
why don't you play a game?

Are we there yet, are we there yet?
she called with a yap.
No, we are not there yet,
why don't you take a nap?

Are we there yet, are we there yet?
We better get there quick,
if you don't stop this moving—
I am going to get sick.

Are we there yet, are we there yet?
cried the little loon.
No, my darling,
but we will be there soon.

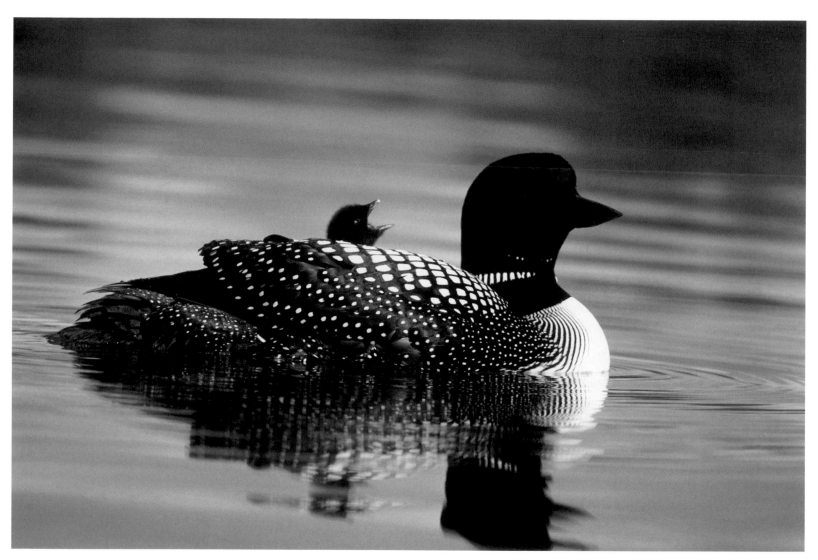

Common loon and her chick

The view forever

Mama takes me up these hills
but never far enough
for me to see around and over
every rock and bluff.

So when I can't see all there is
and want to see whatever,
I climb a little higher
and I can see forever.

18

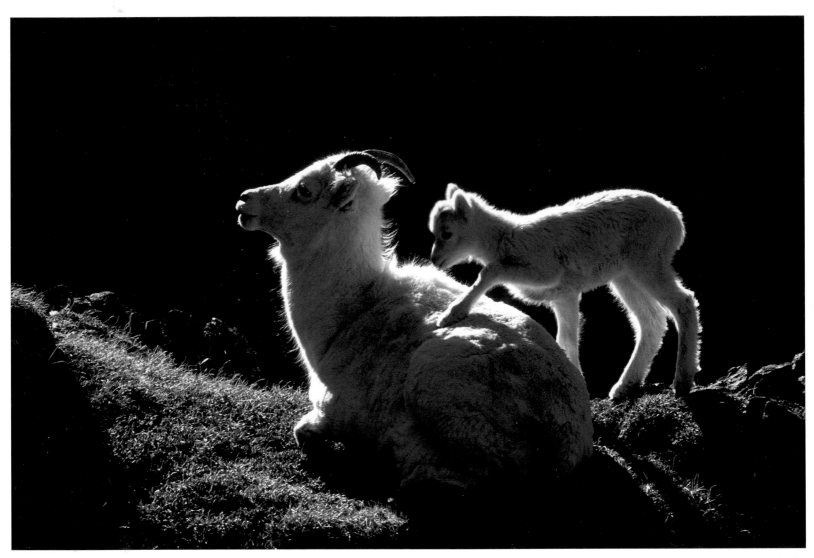

Dall sheep

Camouflage

Camouflage, camouflage,
such a silly word,
three little syllables
sounding so absurd.

But in the woods
it means a lot
and makes me hard to get.
Camouflage, camouflage,
can you see me yet?

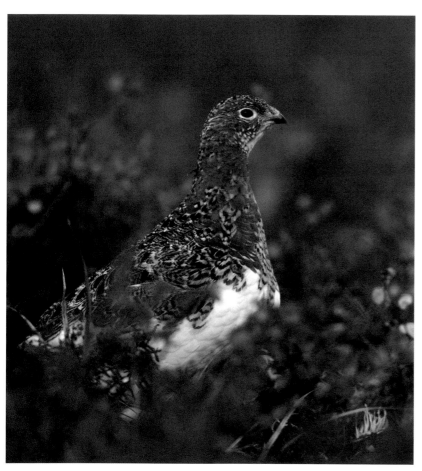

Willow ptarmigan in summer plumage

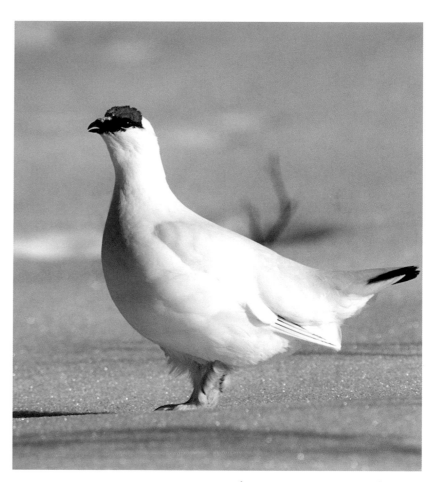

Rock ptarmigan in winter plumage

Oh, for a hide to hide in

It's fun to be a different moose
and wear an all-white gown.
I can go to moose's parties,
act like quite a clown.

But, white I can be spied in
and when hunters come around,
I'd like a darker hide to hide in,
maybe something in plain brown.

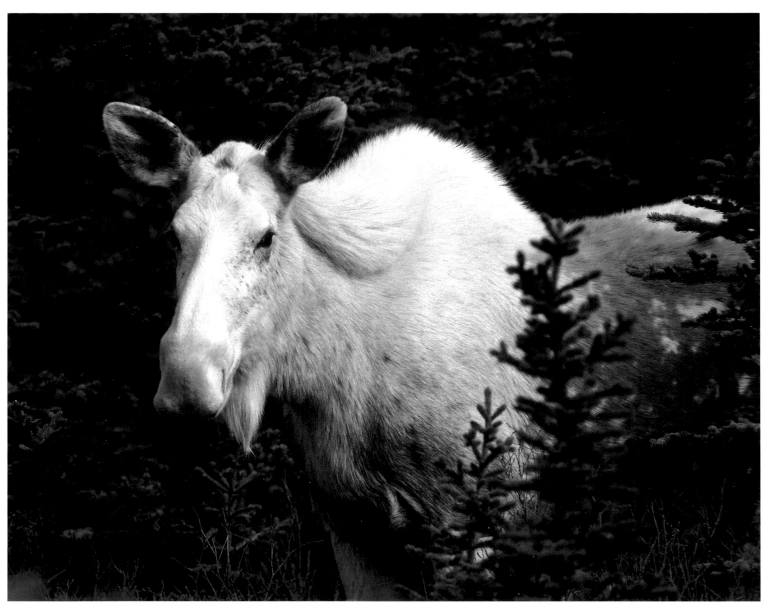

White moose

Sea otter transit authority

Otter ran a ferry trip
from here to over there.
Anyone could ride along
if they paid the fare.

Snow crab asked to take a ride,
to see his buddy bunch.
Climb aboard, the otter said,
we'll even do some lunch.

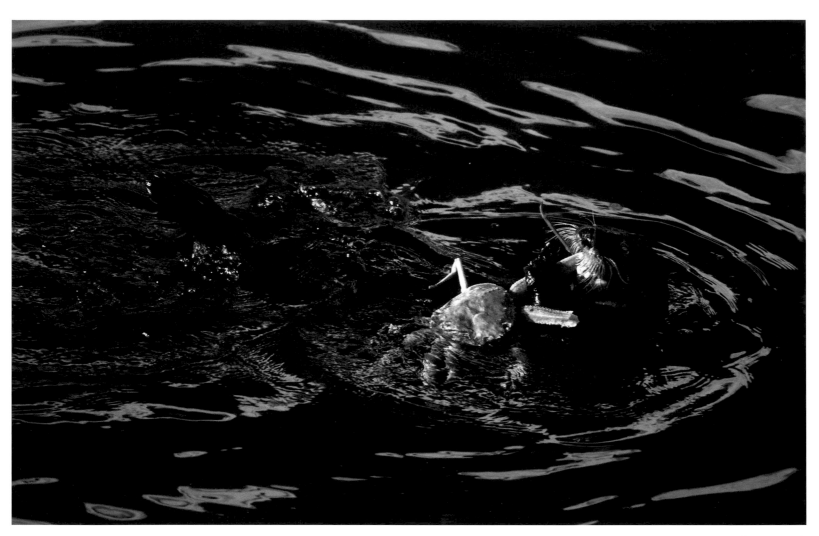

Sea otter and snow crab

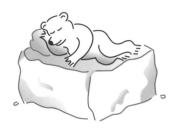

The Arctic waterbed

White bear wanders polar cap
with no rhyme to his heading,
looking for a place to nap,
a place with good soft bedding.

He finds a spot along his hike,
a bed that will suffice,
a comfy place a bear would like,
a nice, white sheet of ice.

But when that sheet is melting,
he'd best arise and get,
otherwise he'll lose his waterbed
and find himself all wet.

Polar bear sleeping

Flower child

I don't do what others do
and some think I'm a snob.
I prefer my fields of flowers
to the madding mob.

Few can understand me
and some say I'm a slob.
All they do is tell me,
"Get a haircut, get a job."

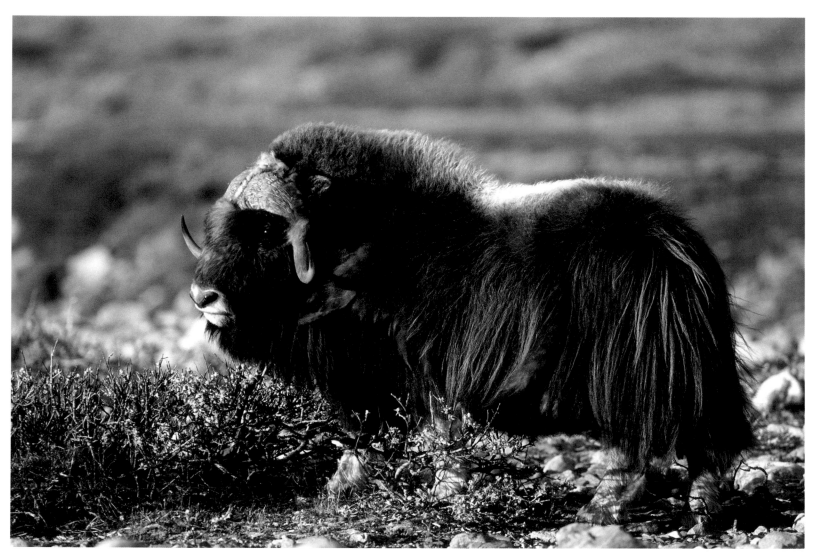

Musk ox

Poor George Bear

Old George bear,
big George bear,
how will you ever
comb your hair?

On a stump,
on a tree,
on a sign you see.

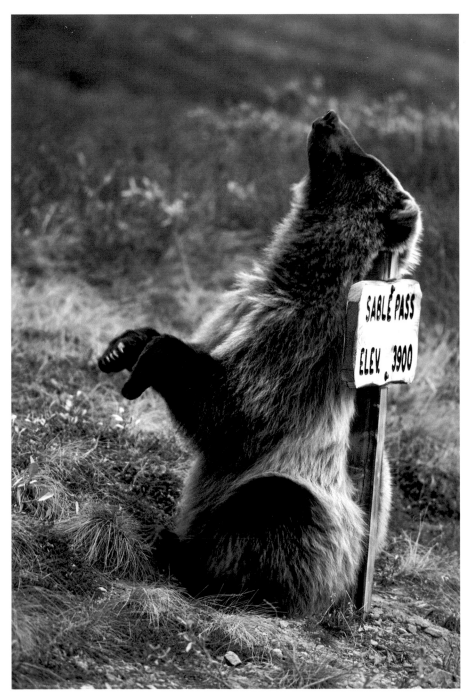

Grizzly bear

Peekaboo caribou

The tundra hasn't anything
that's tall of which to speak;
nothing big to hide behind
when playing hide-and-seek.

With nowhere else to go
to hide from one another,
I found the safest place to hide
is right behind my mother.

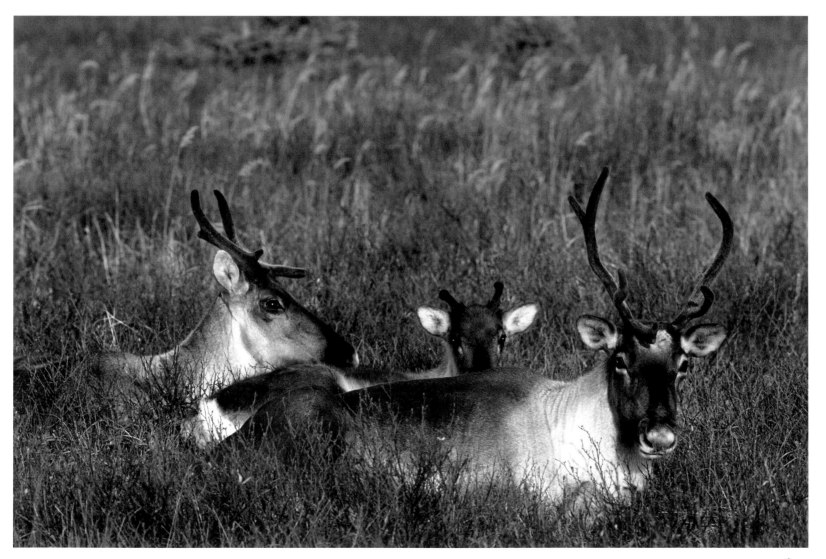

Caribou

Determined ermine

An ermine
in his winter whites
climbed a tree
to see the sights
and get himself
above the snow
that lay so deep
he couldn't go.

Too bad it was
a little twig
and couldn't hold
a thing that big.
It broke when ermine
made a shift
and sent him swimming
in a drift.

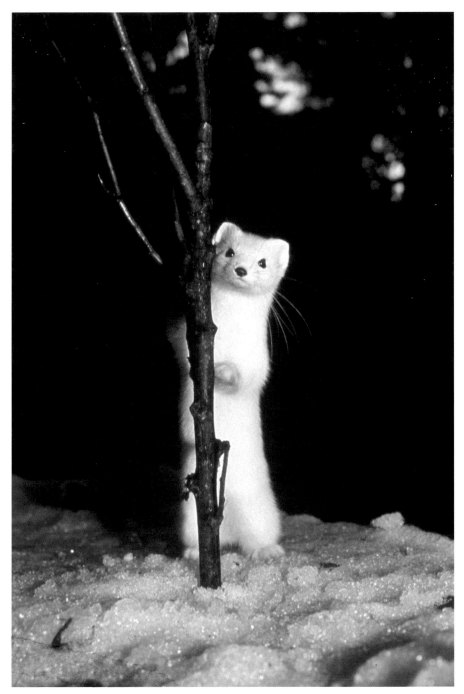

Short-tailed weasel (ermine)

Pfine pfeathered pfashion

Ptarmigan's a natty dresser,
planning plumage with panache.
In winter white's his fashion;
in summer brown's the catch.
In spring he can't make up his mind
and dresses mix and match.

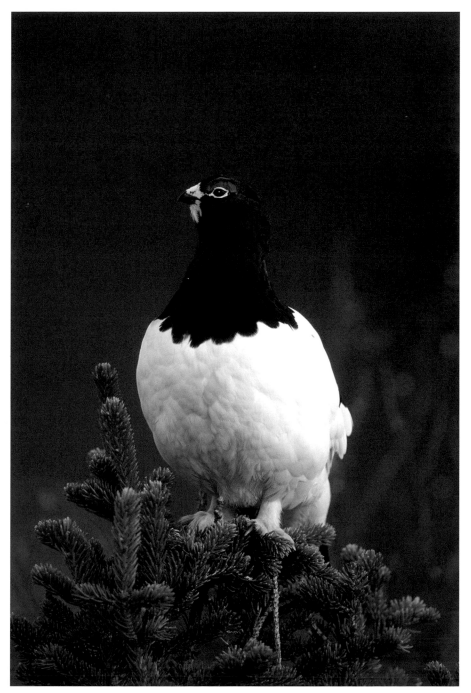

Willow ptarmigan in early spring plumage

The terrible twos

Oh, cubs of mine, oh cubs of mine,
to grow up strong and sound
and be a bear you have to walk
with four feet on the ground.

But, Mama dear, oh Mama dear,
aren't bears allowed to choose
if they want to run on fours
or walk around on twos?

Oh cubs of mine, oh cubs of mine,
grow up to be fine ones.
But you can't be a bear at all
While standing on your hind ones.

But Mama dear, oh Mama dear,
to get food to our jaws,
we have to stretch and reach up high
and stand on our hind paws.

Oh cubs of mine, oh cubs of mine,
to grow you have to eat.
But you won't grow to be a bear
while standing on two feet.

But, Mama dear, oh Mama dear,
if berries we're to find,
we have to walk on twos to see
'round Mama's big behind.

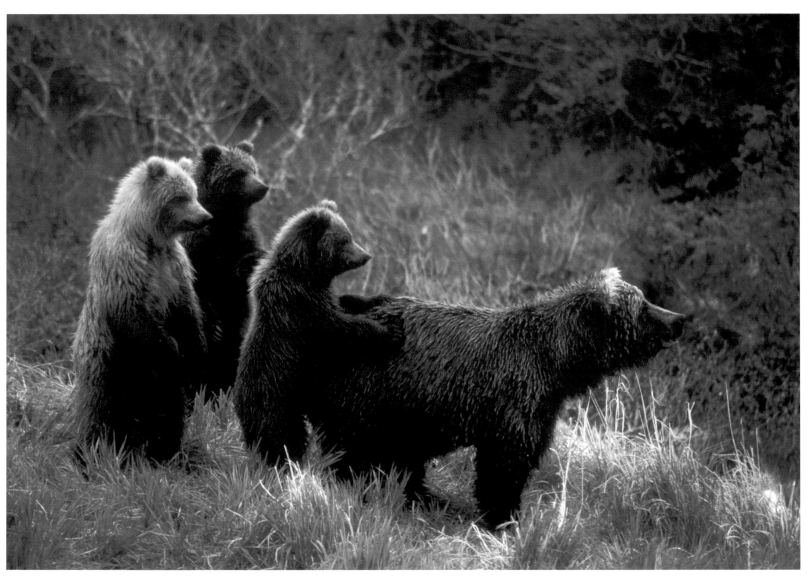

Female grizzly bear and her cubs

Snorkeling

When they put these ponds around,
they should warn us, I contend,
to tell us where it's shallow
and how to miss the deep end.

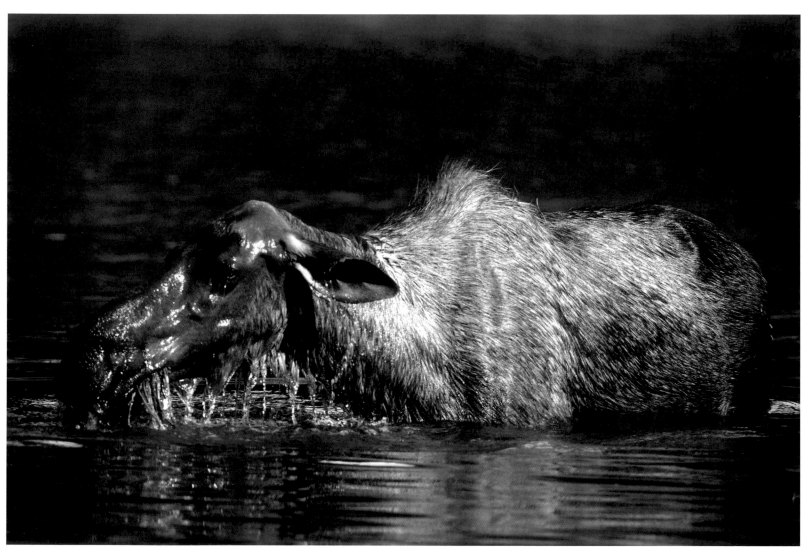

Moose

Cooling your wheels

A snowshoe hare
with racing flair
went hopping 'cross the fields.

The snowshoe hare
with hair to spare
got snow caught in the heels.

The snowshoe hare,
befuddled there,
stopped to clean his wheels.

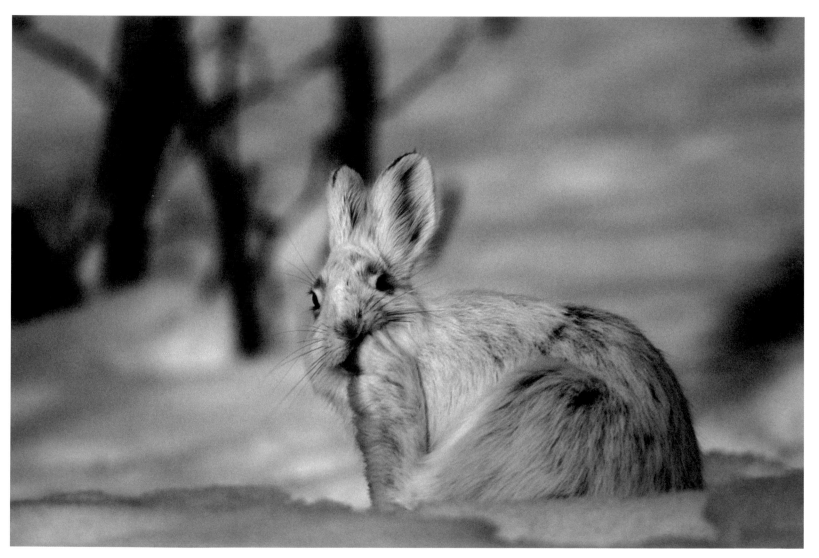

Snowshoe hare

Cool courage

I've stood upon the high rocks
while my muscles twitch and quiver,
as I try to build my courage
to jump into the river.

But just when I'm about to go,
a hot dog blows my hero's dream
and makes me look a coward
as he goes and jumps upstream.

44

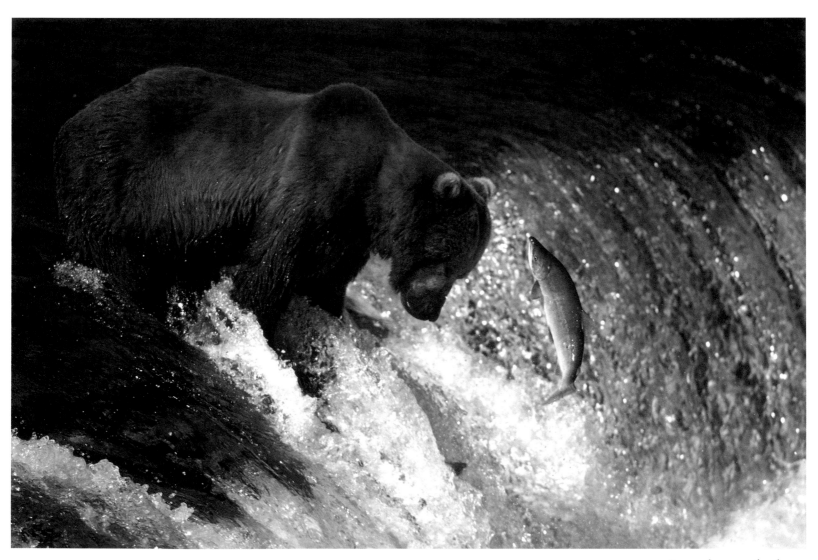

Brown bear and salmon

Whatever can a walrus do?

When I get scared deep in the night
of monsters in the gloom,
I pull the covers way up tight
to chase them from the room.

Whatever can a walrus do
when facing such a fright,
out there lying on the sand
no hiding place in sight?

46

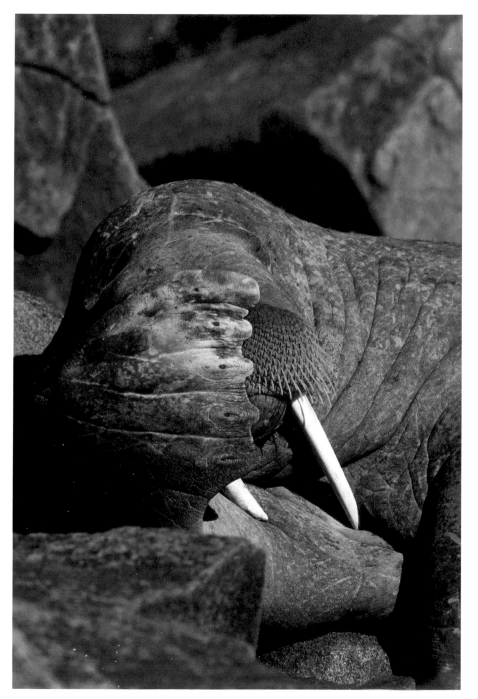

Pacific walrus

PHOTO BY JIM LAVRAKAS

Tim Jones

Tim Jones has lived in Alaska for more than thirty years. In that time he has been a newspaper and magazine editor, a tour boat operator, commercial fisherman and oil-spill response consultant, had a few sailing adventures, and has spent time living in the Bush. His work has appeared widely in magazines and he is the author of several books with Alaska themes including the bestseller *The Last Great Race* and *Keep the Round Side Down*.

Tom Walker

In the forty years that Tom Walker has resided in Alaska, he has worked as a conservation officer, wilderness guide, wildlife technician, log home-builder, documentary film advisor, and adjunct professor of journalism at the Homer Branch, University of Alaska, Anchorage. Now a full-time freelance writer and photographer specializing in natural history and wildlife, Walker is one of Alaska's premier photographers. His work has been published widely and he has published, authored, or co-authored more than fifteen books including *Building the Alaska Log Home, Shadows on the Tundra, Denali Journal, Alaska's Wildlife*, and *Caribou Wanderer of the Tundra*, which won a Benjamin Franklin Book Award in 2000 for best book in the nature/environment category.